STICKY FINGERS

ANIMALS

by Ting and
Neil Morris

illustrated by Ruth Levy

FRANKLIN WATTS

NEW YORK/LONDON / CHICAGO/TORONTO / SYDNEY

 This symbol appears on some pages throughout this book. It indicates that adult supervision is advisable for that activity

© Franklin Watts 1993

Franklin Watts
95 Madison Avenue
New York, NY 10016

10 9 8 7 6 5 4 3 2 1

Library of Congress Cataloging-in-Publication Data

Morris, Ting.
 Animals / by Ting and Neil Morris
 p. cm. – (Sticky Fingers)
 Includes index.
 Summary: Provides step-by-step instructions for making different animals using craft techniques and readily available materials. Information about each animal is included.
 ISBN 0-531-14268-X
 1. Handicraft–Juvenile literature. 2. Animals in art–Juvenile literature. [1. Handicraft. 2. Animals.] I.Morris, Neil. II. Title. III. Series: Morris, Ting and Neil. Sticky Fingers.
TT160. M66 1994
745 592–dc20

93-20415
CIP AC

Editor: Hazel Poole
Designer: Sally Boothroyd
Photography: John Butcher
Artwork: Ruth Levy
Picture research: Juliet Duff

Printed in Malaysia

Contents

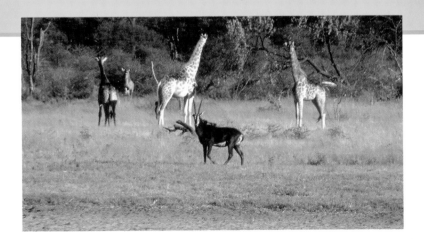

Introduction

In this book you can learn about animals both by reading about them and by having fun with craft activities. The information in the fact boxes will tell you about animals from all over the world - where and how they live, and why many of them are endangered. As the world changes and human beings use up more of the earth's natural resources, so life becomes more difficult for many wild animals. If we learn more about them, perhaps we can help them to survive.

At the end of the book is a map to show you where some of the animals mentioned in the book live. There is also a list of places to visit and books to read if you want to find out more.

So get ready to get your fingers sticky - making animals as you read about them!

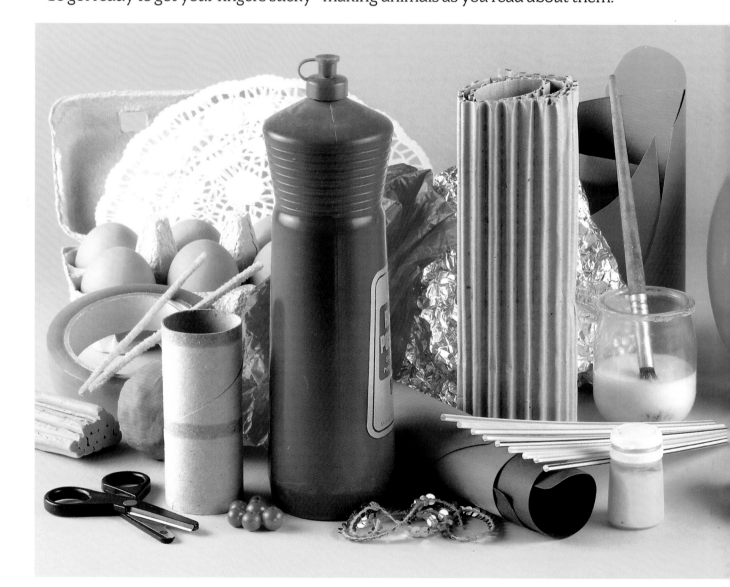

Equipment and materials

The projects in this book provide an introduction to the use of different art and craft media, and need little adult help. Most of the objects are made with throwaway household "junk" such as boxes, plastic bottles and containers, newspaper and fabric remnants. Natural things such as seeds, sticks, sand, and stones are also used. Paints, brushes, glues, and modeling materials will have to be bought, but if stored correctly will last for a long time and for many more craft activities.

In this book, the following materials are used:

air-hardening modeling clay
balloons (round)
beads
bowl (large)
brushes (for glue and paint)
bucket
buttons
candies
cardboard tubes
chairs
comb (old)
cooking oil
cotton thread
craft knife
crayons
cup
dishwashing liquid
egg cartons
fabric scraps
felt-tip pens
felt scraps
flour
foam chips

fork
funnel
garden wire
gloves, black and red
glue (water-based PVA, which can be used for thickening paint and as a varnish; strong glue such as UHU for sticking plastic, metal, and fabric; glue stick)
jar (for mixing paint and paste)
knife
laundry detergent (powder)
marker pen, black
newspaper
paint (powder, ready-mixed, or poster paints)
paper (cardboard and oak tag; corrugated paper; crêpe paper; tissue paper; tracing paper; newspaper; construction paper; white paper)

paper fasteners
pencils
plastic bottle
popsicle stick
rolling pin
ruler
salt
sand
scissors
silver foil
socks (old), white and brown
sponge
stapler
stocking
straws
string
tape (sticky tape; parcel tape)
toothpick
varnish (PVA mixed with cold water)
wallpaper paste (fungicide-free)
water

Paper Tiger

Here's a fun way to make a tiger pencil holder or popcorn holder.

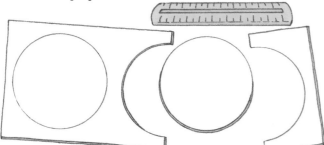

1 Start with the tiger's body, which is made from two containers. For the base of the containers, draw two circles about 3 in (8 cm) in diameter onto some cardboard. Cut out the two cardboard disks.

2 Now cut two long strips of corrugated paper, about 10 in (26 cm) long and 4 in (10 cm) wide. The corrugated lines should run across the width of the strips. Paint the strips orange.

3 When the strips are dry, cut 1/2-in (1- cm) slits into every second corrugated line.

4 Fold in the fringed border of the corrugated paper and roll each strip into a tube the right size to fit the cardboard base. Tape each tube at the side before gluing it onto the base.

5 Staple the two tubes together as shown. To complete the tiger's body, cut some black strips of paper and stick them onto the tubes to look like stripes.

6 The tiger's head is made from a rectangular piece of cardboard, with two circles for eyes. Add two corrugated paper ears and secure them with tape at the back. Paint the head orange to match the body.

7 Cut out a pair of cream construction paper eyes and black pupils. Make a nose by folding a piece of black construction paper in half and cutting it to shape. An orange card ring makes a friendly tiger smile.

8 Glue on the eyes and nose. Now tape the head to the body.

9 Help the tiger to sit comfortably by gluing on four corrugated paper legs. Don't forget to staple on a long construction paper tail.

Now that your tiger is finished, why not fill him with popcorn and start munching?

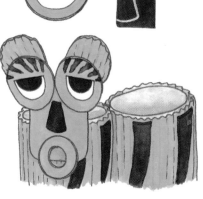

Tigers

Tigers are "big cats," a group of the cat family. Today they are mostly found in the jungles and forests of Asia. They are usually about 10 feet (3 m) long, but the Siberian tiger (above) can reach 13 feet (4 m) in length. It is the biggest of all cats, and its fur is long and thick which keeps it warm in the cold winters. The Indian, or Bengal, tiger lives in a much warmer southern climate and is smaller, with shorter, thinner fur.

Tigers usually hunt alone and at night, feeding on antelopes and other animals. They sometimes travel great distances to find food and water.

A tigress usually gives birth to two or three cubs. At the age of six or eight weeks, the cubs start to go hunting with their mother. They usually stay with her for at least a year, until they can hunt for themselves.

Today, tigers are in danger of dying out. Many have been killed for sport, although there are strict laws about hunting. Their natural homes are also being destroyed, along with their major food source of wild pigs, buffalo, and deer.

Panda Puppets

YOU WILL NEED:
- ✔ 2 old socks, white and brown ✔ scissors
- ✔ 2 gloves, black and red ✔ strong glue
- ✔ black, white, and brown felt ✔ string
- ✔ fabric or tissue paper for stuffing
- ✔ black marker pen ✔ 2 buttons

1 To make the giant panda's head, loosely stuff the foot of a white sock with fabric or tissue paper. Put on the black glove and push your gloved hand into the sock, so that your three big fingers can work the head. Tie some string around the neck, but leave it loose enough for your fingers to go in and out.

2 Cut two small holes in the sock below the neck. Pull the thumb and little finger of the glove through the holes to make the panda's arms.

3 Stick two black felt circles to the panda's head for the ears.

4 For the eyes, cut out two black rectangular felt shapes and two white circles. Glue the circles in the middle of the rectangles, draw black dots for pupils, and then glue the eyes into position.

Pandas

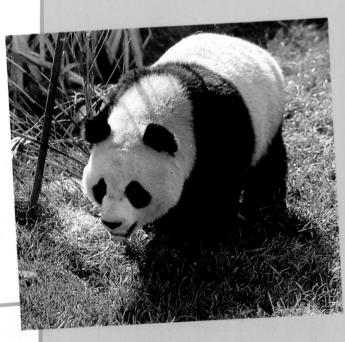

Giant pandas (left), with their black and white markings, are very rare. They live in the mountainous bamboo forests of Western China, and are now protected by law in China. Giant pandas spend most of their time eating. In the summer they eat young bamboo shoots, and in the winter they feed on stalks and leaves. They grow up to 5 feet (1.5 m) long and can sometimes weigh more than 330 pounds (150 kg).

The red, or lesser, panda (right) is smaller and lives in Western China and in the forests of the Himalayas. Red pandas feed on roots and insects as well as bamboo. They have reddish-brown fur and a long bushy tail and are related to the raccoons of North America.

5 Finally, stick on a black felt nose and a friendly mouth. Slip your gloved hand into the panda's head and make him nod to say hello.

6 You could use the same method, with a brown sock and a red glove, to make a red panda. Add some brown felt ears and sew on two button eyes. To make the long striped tail, cut a strip of brown felt and mark it with black marker pen. Stick the tail to the brown sock body.

Now you can have fun with a different panda on each hand!

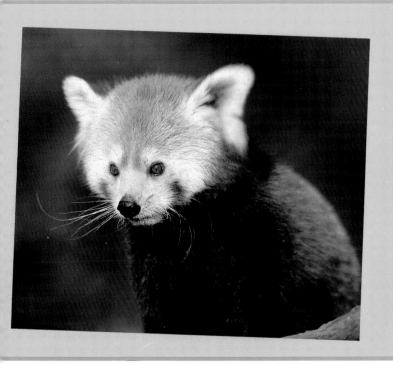

Penguin Bookend

YOU WILL NEED:
- ✔ plastic bottle ✔ sand or salt ✔ newspaper
- ✔ wallpaper paste (fungicide-free) ✔ tape ✔ cup
- ✔ black poster paint ✔ white ready-mixed paint
- ✔ varnish ✔ brushes ✔ funnel ✔ scissors
- ✔ thick cardboard

1 Pour two cupfuls of sand or salt into an empty plastic bottle, using a funnel or paper cone. The sand or salt will keep the bookend from tipping over.

2 Screw one sheet of newspaper into a ball and then wrap it in another sheet. Twist the four corners of the second sheet together, making a neat ball for the penguin's head.

3 Push the twisted end of the head into the bottle.

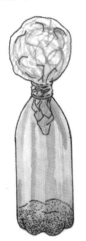

4 To make the beak, cut a circle, 3 in (8 cm) in diameter, from a piece of thick cardboard. Cut a segment out of the circle as shown. Pull the edges together and fasten them. Tape the cone beak to the head.

5 Tear some newspaper into thin strips, about $3/4$ in (2 cm) wide. Mix the wallpaper paste as instructed on the package and coat the strips of newspaper with it. Pull each strip between your finger and thumb to remove any lumps.

6 Paste four layers of newspaper strips over the head, beak, and neck of the bottle. Let it dry for a while. Add another three layers of coated newspaper strips. Let it dry thoroughly, which might take a few days.

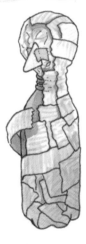

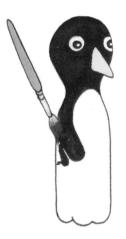

7 When the figure is dry, paint it with white ready mixed paint. Wait for this to dry and then paint the head black, leaving white circles for the eyes and adding black dots for the pupils. Paint the penguin's back black too, and add black flippers. For a shiny finish, varnish the whole model.

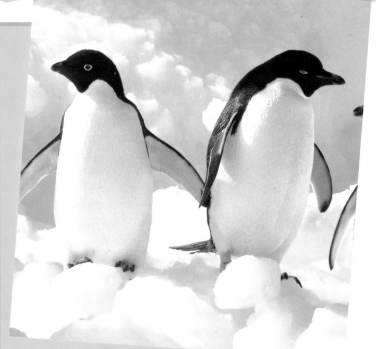

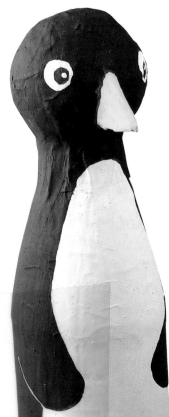

Penguins

Penguins are birds, but they cannot fly. Their wings are flippers, and they use them to swim at speeds of nearly 30 miles (50 km) an hour. On land, penguins use their flippers for balancing as they walk. Sometimes they flop on their bellies and toboggan across ice and snow. Penguins spend most of their lives in the water. They come on land mainly to produce their young, living together in breeding grounds called rookeries. A rookery may contain as many as one million penguins! Many species, including the Adélie (above) and chinstrap penguins of the Antarctic, build nests of stones. The male and female take turns sitting on the nest and keeping the eggs warm. While one is on the nest, the other goes to sea to feed on fish. Chicks leave the nest when they are about 4 weeks old. Sometimes harsh weather kills the eggs or chicks, but the parents usually manage to raise one chick to full growth.

When it's dry, you can put your penguin bookend to use. Have you got any books on the Antarctic to prop up?

Jumping Jack Monkey

1 Copy these monkey shapes onto oak tag and cut them out. Remember to draw two arms and two legs, and turn one of each over before coloring them in.

2 Draw the monkey's face with felt-tip pen. Color in the body with crayon, making it look like fur.

3 Ask an adult to make ten holes in the pieces, as marked. Then fit your monkey together with **paper fasteners**. **Don't make them too tight — make sure the arms and legs can move freely.**

4 Join the arms and legs together at the back with string as shown. Then, with the arms and legs in the outstretched position, link the two strings with another piece of string, as shown. Leave a length of string hanging down at the front and tie a bead to the end.

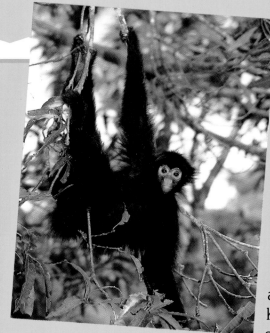

New World monkeys

The New World monkeys of South and Central America are generally smaller than monkeys found in Asia and Africa. They live in trees and are mainly vegetarian. Most sleep at night and are active only in daylight. Marmosets and tamarins are small monkeys, which have claws instead of fingernails. Many have tufts of hair on their ears, face, or neck. All other New World monkeys belong to one family, but they vary in appearance. Spider monkeys (left) are long-legged creatures that use their tail as a fifth hand. Squirrel monkeys live in large troops and scamper about in the trees. Capuchins also live in the trees and use their long tails to grasp branches. Owl monkeys have big eyes and come out at night. Howlers are so called because the males have an extremely loud calling voice.

5 Attach a string loop to the back of the head with parcel tape. Then you can hang the monkey on your wall. Pull on the bead and watch him jump!

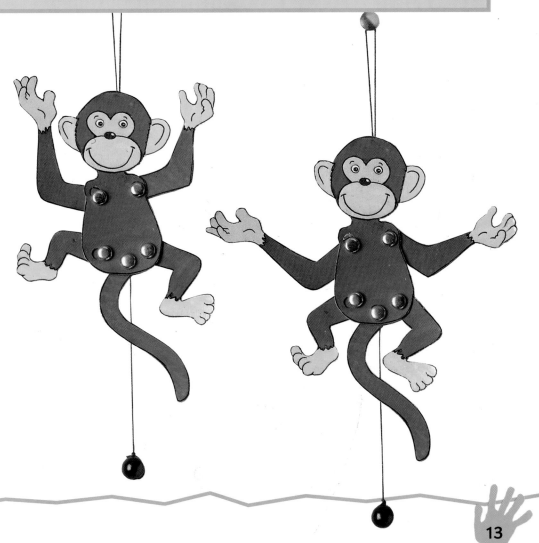

The Great Kangaroo Race

1 First, trace this picture of a joey.

YOU WILL NEED:
✔ tracing paper ✔ card ✔ felt-tip pens ✔ chairs
✔ string (10 ft (3 m) for each racer) ✔ scissors
✔ pencil

2 Cut out the tracing-paper shape and draw around it onto some cardboard. Cut out the joey and ask an adult to make a hole just below the head, big enough for string to run through easily.

Marsupials

Marsupials are mammals that give birth to tiny, immature young. Most female marsupials have a pouch on their underside. As soon as they are born, the young crawl into the pouch and feed on their mother's milk. They stay there for several months. Most marsupials are found in Australia and New Guinea. They include kangaroos, wallabies (left), koalas, bandicoots, and wombats. The only marsupials outside the Australian region are the American opossums. Kangaroos grow to about 6 ft (1.8 m) tall and usually travel in herds. Australians call big male kangaroos boomers. A young kangaroo is called a joey.

3 Make more identical kangaroo racers — as many as there are players. Color them in and number their pouches 1, 2, 3, and so on.

4 Thread each kangaroo onto a length of string and tie one end to the leg of a chair. Lie the racers on their backs, with their racing numbers showing.

5 Mark a start line about 10 ft (3 m) away from the chair, and a finish line near the chair.

6 Now each player takes a string and races their kangaroo by pulling on the string and then letting it go. Let each player practice a bit before starting. *(Here's a racing tip: don't jerk too hard or your racing joey will somersault backward.)*

The first racer to cross the finish line wins the great kangaroo race!

Noah's Ark

YOU WILL NEED:
- ✓ air-hardening modeling clay
- ✓ poster paints
- ✓ water ✓ knife
- ✓ toothpick ✓ straws
- ✓ cardboard ✓ rolling-pin ✓ brushes
- ✓ scissors ✓ small box

In the Bible story, Noah builds an ark because the earth is going to be flooded. The ark holds Noah's family and two of every kind of animal in the world. Our ark can't do that, but we are going to fill it with some of the biggest animals in the world — those of the African savanna.

1 To make the ark, flatten a ball of clay and roll it into an oval to form the bottom of the boat. Then roll some clay into a sausage shape as thick as your finger. Fit this coil carefully around the edge of the bottom of the ark. Now build up the sides of the ark with two more coils, one on top of the other, leaving a gap for the gangplank. Moisten the edges and seams with water to help them stick.

2 For the cabin, roll out some clay and cover a small box. Then roll out some clay to make the gangplank, and mark the "boards" with a toothpick. Now make some animals to go up the gangplank.

3 To make a tall giraffe, roll out a thick clay sausage for the body. Cut the ends, bend it, and stand it up. Roll out a long, thin sausage, and shape one end to make the head. Mark the eyes with a toothpick. Put the two pieces together by moistening the seam. Add triangular ears and a tail.

4 Make a big elephant by rolling a lump of clay into a ball for the body. Make a smaller ball for the head and stick them together.

For the elephant's legs, cut a fat clay sausage into four equal parts and stick them to the body. Smooth the seams together.

A thin sausage makes the trunk and tail. Flatten two lumps of clay for the big ears and stick them to the head. Cut two tusks out of cardboard and push them into the clay. Mark the eyes and trunk with a toothpick.

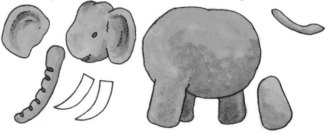

5 You can use the same method to make a rhino and a lion, stretching and pulling the clay ball into the animal shape. Press two cardboard triangles into the clay for the rhino's horns. Use cut-up straws for the lion's mane.

6 Finally, make a zebra. Roll out two sausages for the legs. Then roll a thicker piece for the body. Join them together in an "H" shape, smooth the seams, and bend the legs down.

Add a piece of clay for the head and neck, and don't forget to give your zebra ears and a tail.

Animals of the savanna
The savanna is an area of open grassland, scattered with bushes and some flat-topped trees. In Africa, the savanna borders on tropical rain forests and deserts. These grasslands are the home of great herds of animals. The African elephant is the largest land animal, standing 10 to 13 feet (3-4 m) high and weighing 3 to 6 tons. The leader of an elephant herd is usually an old female. The giraffe is the tallest animal, some standing more than 18 feet (5.5 m) high. African rhinoceroses have huge, heavy bodies and two horns above their nostrils. They usually travel alone, but are sometimes found in small family groups. Zebras and antelopes live in herds and are hunted by lions. The "king of beasts" lives in prides of between 10 and 35 lions.

7 When the animals are dry, paint them before putting them into the ark.

Why not make more birds and animals to go into your ark?

Tortoise Surprise

Tortoises are very slow animals, and this one takes quite a long time to make!

YOU WILL NEED:
- ✓round balloon ✓3 toilet paper tubes ✓newspaper ✓tissue paper
- ✓wallpaper paste (fungicide-free) ✓buttons ✓PVA glue ✓✓brush
- ✓wrapped candies ✓green poster paint ✓string ✓warm water
- ✓scissors ✓bucket ✓craft knife

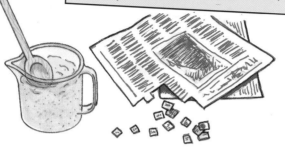
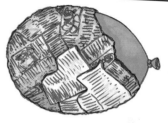

1 First tear up some newspaper into lots of $^3/_4$-inch (2-cm) squares. To make paper pulp, fill a bucket with paper pieces. Pour some warm water into the bucket and leave the paper to soak. When the paper is soft, rub it into a pulp. Then squeeze out the water. Mix the wallpaper paste as instructed on the package, and stir it into the pulp until the mixture is like sticky pastry. *(Keep any unused paste in a separate sealed container.)*

2 For the tortoise's body, blow up a balloon. Cover it with the pulp and press some dry newspaper pieces into the paste. Smooth out any air bubbles, and cover the balloon with three layers of pulp and paper.

3 Cut two toilet paper tubes for legs as shown, and cover each leg with a layer of pulp and newspaper pieces.

4 Stick the curved edge of the legs to the body, using pasted strips to hold them in position.

5 Use another toilet paper tube to make the neck. For the head, make a paper ball and stick it into the open end of the neck. Stick it to the body with pasted strips.

6 Now cover the head, neck, legs, top, and sides of the tortoise's body with paper pulp and smooth the pulp with your hands. Don't cover the underside. Then leave the tortoise to dry, which might take a few days.

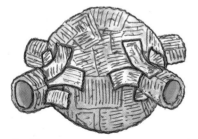
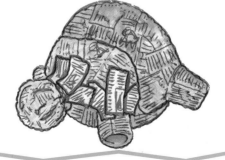

7 When your tortoise is dry, ask an adult to cut an opening in the underside. Then fill it with candy and cover the opening with tissue paper.

8 To hang up the tortoise, make a small hole in the top of the body. Push the knotted end of a piece of string into the hole and put PVA glue and pulp around the hole. Let this dry.

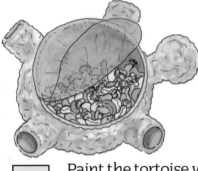

9 Paint the tortoise with green poster paint and glue on pieces of colored tissue paper to make a shell. Stick on some button eyes.

Turtles and tortoises

Sea turtles are marine, or water, reptiles with paddle-like flippers and a stream-lined shell. They can be found in most seas and often travel long distances to lay eggs on their favorite nesting beaches.

It is thought that the first turtles lived on earth more than 185 million years ago and that they have changed very little since then.

The largest turtle is the leatherback, which is found worldwide. It can be over $6\frac{1}{2}$ feet (2 m) long and weigh over 1,000 pounds (500 kg). The leatherback has a thick, leathery skin covering its shell. Turtles are graceful and swift swimmers, but clumsy and slow on land.

Land-dwellers are usually called tortoises. A rare type of giant tortoise (below) lives only on the Galapagos Islands in the Pacific Ocean. It can grow up to 5 feet (1.5 m) and has a big, high-domed shell.

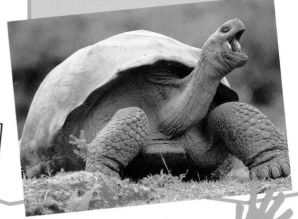

You can play a good party game with your tortoise by hanging it up and using it as a Mexican piñata. Blindfold one of your friends, give them a rolled-up newspaper to use as a stick, and then spin them around. If she or he manages to hit the tortoise, they may have a sweet surprise!

Rainforest Screen

1 Cut off the top, the bottom, and one side of a large cardboard box, leaving just three sides. These will form your screen. Stand it up to see how it looks.

YOU WILL NEED:
- ✔ large cardboard box
- ✔ green powder paint
- ✔ yellow, green, and brown ready-mixed paint
- ✔ crayons ✔ PVA glue
- ✔ strong glue ✔ tissue paper
- ✔ construction paper ✔ tape
- ✔ silver foil ✔ crêpe paper
- ✔ corrugated paper ✔ scissors
- ✔ felt scraps ✔ old stocking
- ✔ foam chips or fabric stuffing
- ✔ fine sand or salt ✔ oak tag
- ✔ brushes (for glue and paint)
- ✔ cardboard

2 Lie the screen flat while you are working on your picture. You can mark the position of trees and animals with crayon. Cut out some tall corrugated paper tree trunks. Paint them different shades of green and brown and stick them onto the screen. Stick crêpe- or tissue-paper vegetation on top.

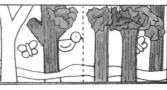

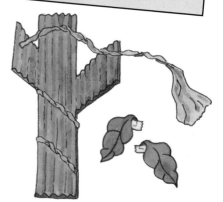

3 Make lianas (climbing plants) from strips of twisted crêpe paper, and wind them around the tree trunks. Cut leaf shapes from paper and tape only the stems to the tree, to produce a three-dimensional effect.

4 Cut out some colorful construction paper petals and stick them to the trees. Make clusters of fruit with crumpled-up tissue paper.

5 Use crunched-up silver foil for a rain forest river. Stick the foil to the bottom of the screen and cover the forest floor with green vegetation. To make the vegetation, mix fine sand or salt with dry green powder paint. Brush glue between the plants and the river. Then sprinkle the colored sand over the glue while it is still wet. Pick the screen up and shake off the loose sand.

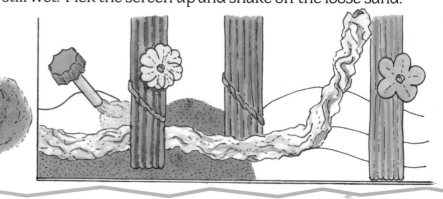

6 For the bird's body, cut a cardboard circle, 2 inches (5 cm) in diameter. Fold it in half.

For the head, draw two small circles. Cut them out, stick them onto each side of the body and join them together. Add some eyes.

Fold a piece of colored paper as shown to make the tail. Stick it into the body and cut the end at an angle.

To make the beak, fold a rectactangular piece of cardboard in half and cut away the shaded areas shown here. Make a small cut in the fold and slot the beak onto the bird's head.

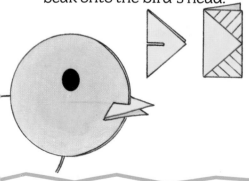

Animals of the rain forest

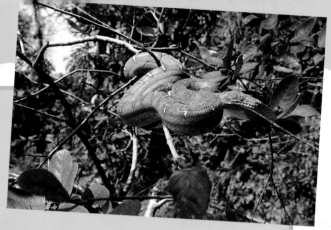

Many different types of animals live in tropical rain forests. In South American forests, howler and spider monkeys swing from the branches. The howler's booming call might be accompanied by the harsh cries of a blue and gold macaw, a large tropical parrot with a long tail and brilliant plumage. The toucan, with its huge, brightly-colored bill, also lives here. Lower down, there are rain forest reptiles. The emerald tree boa (above) winds its body around branches. This snake has very long teeth which help it to catch and hold birds. Many insects make their home here, too. The hercules beetle has two large curved horns, and the huge morpho butterfly has beautiful, bright blue wings. Jaguars live deep in the forest. All these animals form part of the balance of nature which will sadly be lost if the rain forests continue to be destroyed.

7 For a slithering snake, stuff a stocking with fabric or foam and knot the end. Make eyes and a mouth out of felt scraps. Add the snake's markings with paint thickened with PVA glue. Wrap the snake around the top or side of the screen.

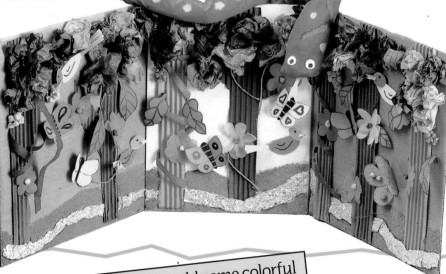

Why not add some colorful oak tag butterflies?

Sea World

YOU WILL NEED:
- ✓ large shallow cardboard box ✓ scissors
- ✓ construction paper ✓ felt-tip pens
- ✓ large sheet of white paper ✓ tape ✓ PVA glue
- ✓ glue stick ✓ pink tissue paper ✓ sponge
- ✓ powder detergent ✓ dishwashing liquid
- ✓ green, blue, and yellow powder paint
- ✓ cotton thread ✓ comb (old) ✓ water
- ✓ brushes (for glue and paint)

1 To turn your box into a tropical sea world, cut it as shown here.

2 Mix three tablespoons of powder detergent with six spoonsful of blue powder paint. Add some water until the mixture is thick and creamy. Make up the same amount of green paint. Paint the inside of the box with layers of blue and green. Make gently swirling currents with your fingers. Wash your hands.

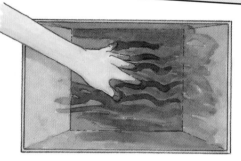

3 While the sea background is drying, you can start on the underwater vegetation. Mix up some yellow, blue, and green powder paint by mixing each color with dishwashing liquid and a little water. Sponge the yellow paint onto a sheet of paper, adding green and blue blobs. Make twirling patterns with a comb.

4 When the painted paper is dry, add some wavy sea plants with felt-tip pen. Leaving a fold along the bottom edge of the paper, cut around the plants. Stick the fold to the bottom of your box. For bits of coral reef, crumple up pink tissue paper and glue different-shaped clusters to the bottom.

5 Cut lots of fish, big and small, from construction paper. Color them brightly with crayons and felt-tip pens.

6 Cut different lengths of cotton thread and stick them to the fish.

Tape the threads to the top of the box and take a dive into your own sea world.

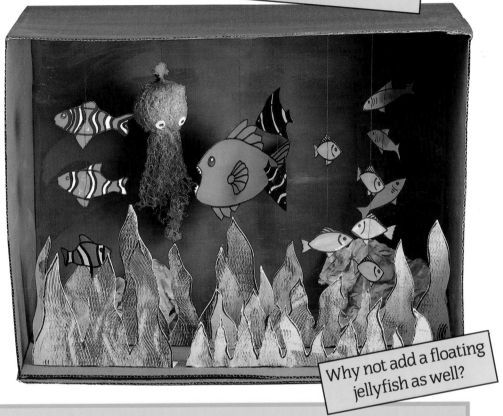

Why not add a floating jellyfish as well?

The Great Barrier Reef

This is the largest group of coral reefs in the world, stretching for 1, 250 miles (2,012 km) along the coast of Queensland, Australia. It is separated from the mainland by shallow water. Coral reefs are built up by millions of tiny sea animals called coral polyps. Along with algae, these deposit limestone, and bind together to form a reef. Over millions of years, the reef has become many feet thick, with an outer layer of living coral. The Great Barrier Reef is the world's largest marine park. Almost 1,500 different species of fish live in its waters. Brightly colored angelfish, butterfly fish, spiny-finned surgeonfish, and manta rays all live and breed there. The warm waters are also home to 4,000 species of shellfish, as well as sea turtles. The entire reef area is protected, and it is illegal for divers to break off or take away coral.

Cardboard Crocodile

1 With a large supply of oak tag and crêpe paper you can create an enormous crocodile. Use four large pieces of oak tag of equal width and varying lengths to make tubes of different sizes. Tape each tube as shown so that one opening is a bit smaller than the other.

2 The smallest piece of oak tag should form a cone shape for the tail.

3 Fit the four tubes into a rocket shape and tape them together. Now you have made the crocodile's body.

4 Use three flat egg carton tops for the top jaw and three for the bottom jaw. Tape the cartons together.

5 Attach the jaws to the body.

6 Cut strips of crêpe paper 4 inches (10 cm) wide. Wet them with diluted PVA glue and wrap them around the whole body and jaws.

7 Use toilet paper tubes covered with crêpe paper to make four legs. Stick clawlike feet, made from black cardboard, to the bottom of each leg. Attach the legs to the body with tape. Wrap crêpe paper strips around the seams.

8 Line the inside of the mouth with pink construction paper, cut to shape.

Crocodiles and alligators

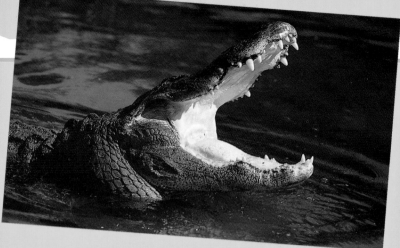

Crocodiles and alligators are large reptiles belonging to a group called the crocodilians. They all have large powerful jaws and long tails, and their skin is like hard leather. They spend their lives in or close to water, mostly in freshwater lakes, rivers, or swamps, but sometimes in coastal waters. They swim with twisting strokes of their tail, holding their short legs close to their body. Crocodiles have long, pointed snouts and live in parts of North and South America, Australia, Africa, and Asia. Large crocodiles grow up to 20 feet (6 m) in length. Alligators (above) have a broad, rounded snout and live in China and in the Americas, including southern Florida. Crocodilians lay eggs and some mothers carry the young in their mouths to the water's edge. They stay there for several months, learning to swim and catch food. Crocodilians feed on fish, birds, and almost any other animal they can catch!

 9 Cut strips of jagged teeth from white cardboard. Glue them to the jaws.

Add two red cardboard circles for his nostrils, and two big yellow cardboard eyes. Draw the pupils with black felt-tip pen.

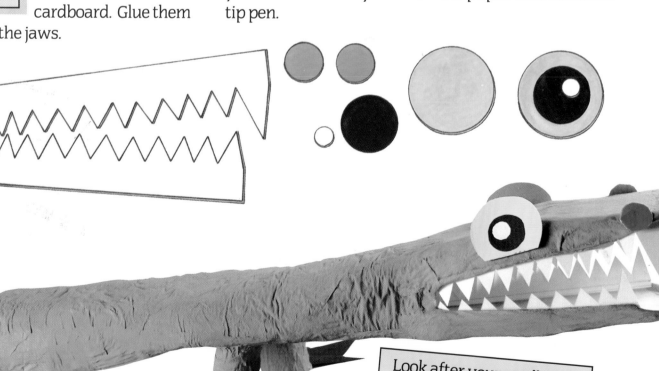

Look after your cardboard crocodile. In zoos, some crocodiles have been known to live to an old age of 66!

Termitarium

Worker termites build their termitarium with particles of soil. You can make a model of a termites' nest with lumps of dough.

YOU WILL NEED:
- ✔ shoe box lid or other cardboard base
- ✔ 6 cups of flour ✔ 3 cups of salt
- ✔ 3 tablespoons of cooking oil ✔ fork
- ✔ water ✔ gardening wire ✔ large bowl
- ✔ white and brown ready-mix paint
- ✔ brushes ✔ popsicle stick

1 Mix the flour and salt in a large bowl. Add the cooking oil and enough water to make a pliable mixture. Knead and squeeze the mixture until it feels like clay. If it is too dry, add more water. If it is too wet, add more flour.

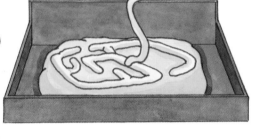

2 Put a large lump of clay in the middle of the shoe box lid, and pat it into a wide base. Now you can build the ground floor of the termitarium. Roll out a long dough sausage and use it to build a maze of narrow passages. Shape small rooms with lumps of dough and make a big room for the queen. In real life, the whole nest is full of passages, right up to the top!

3 Now you can cover the inside of the nest. Place most of the dough on top of it, and form it into a high structure. Make a mountain with crags and peaks. Use a popsicle stick or fork to give a rugged texture, copying the photograph of a real nest. Then paint the termitarium brown.

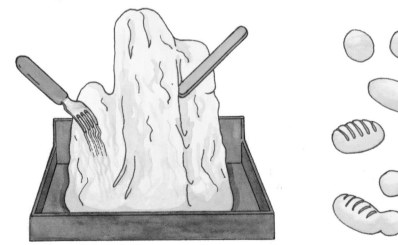

4 You could make some workers, the termites that build the nest, with any leftover dough. Roll a round head in the palm of your hand. Then make a pear-shaped body and mark segments with a popsicle stick.

5 Stick the head and body together with water. Ask an adult to cut some short lengths of gardening wire for legs and feelers. Bend the six legs and two feelers into position and stick them into the dough. Make lots of worker termites.

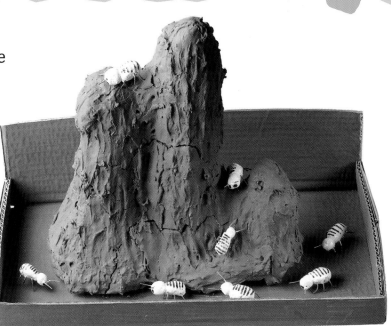

6 Paint the termites white and arrange them around the termitarium.

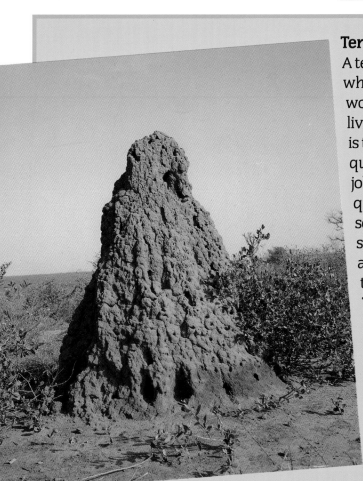

Termites

A termite is a type of worm, sometimes called a white ant. They like to eat wood, and can be found worldwide, especially in warm countries. They live in colonies in three separate groups. The first is the royal group. Each colony has a king and queen - fully developed winged termites whose job it is to reproduce. It is thought that kings and queens sometimes live for up to 50 years. The second group is made up of workers who are small, blind, and wingless. They make the nest and collect food for the colony. The third group, the soldiers, have hard heads and strong jaws. They defend the colony against attack, mainly from ants.

Some termites build huge mounds from bits of soil mixed with saliva. These nests contain a maze of narrow passages with small rooms to store food and eggs. There is a large room for the queen. The mounds can be 20 feet (6 m) high and 15 feet (5 m) across at the base.

Animals Around the World

 Giraffe

 Koala

 Penguin

Crocodile

 Turtle

 Elephant

 Rhinoceros

 Lion

 Panda

 Indian Tiger

 Angelfish

 Kangaroo

North America

Central America

South America

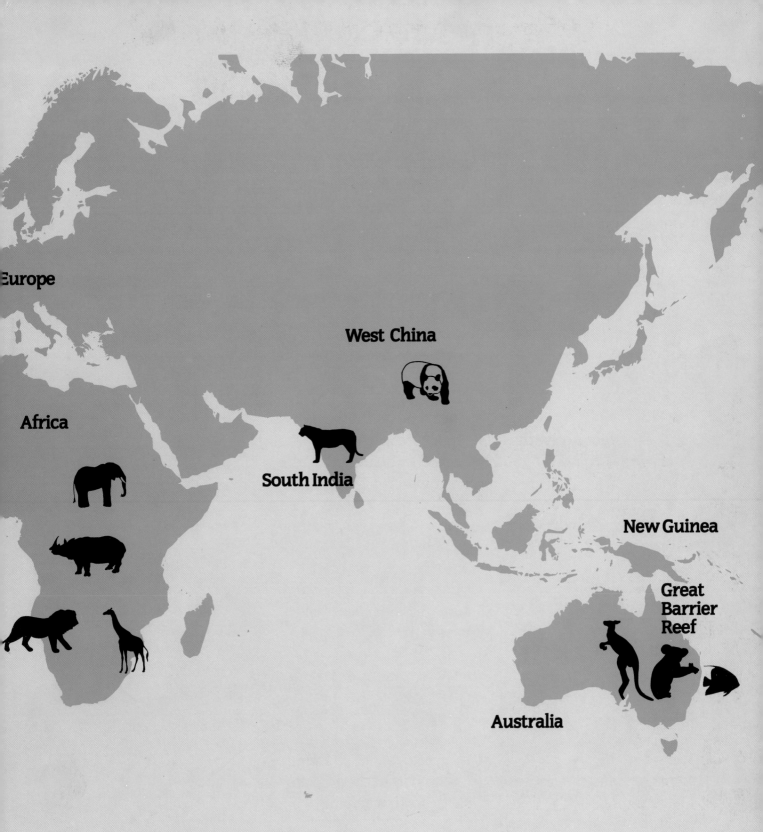

Europe

West China

Africa

South India

New Guinea

Great
Barrier
Reef

Australia

Antarctica

Glossary

Amazon forest - the tropical rain forest around the Amazon River in Brazil, South America; the biggest rain forest in the world.

bamboo - a tall treelike grass, one of the world's fastest growing plants

colony - a large group of animals living together

continent - one of the earth's large landmasses

coral - tiny sea animals and plants bound together, forming a reef

crocodilians - crocodiles and alligators

cub - a young tiger, lion, bear, etc.

Himalayas - the highest mountain range in the world, in South Asia between China and Nepal

litter - a group of baby animals produced at one birth

mammal - a warm-blooded backboned animal whose young feed on their mother's milk

marsupial - a pouched mammal

New World monkeys - a family of different monkeys living in Central and South America. New World is another name for the Americas.

pride - a group of lions

rain forest - thick forest found in tropical areas of heavy rainfall

reptile - a cold-blooded backboned animal, such as a snake or a crocodile

rookery - penguins' breeding ground

savanna - open grassland scattered with bushes and trees in tropical Africa

snout - the nose and jaws of a crocodilian or other animal

species - a group of related animals or plants; for example, lions and tigers are different species of the cat family

tropical - situated in the tropics, the hottest part of the earth's surface near the equator

vegetarian - an animal that eats only plants, not meat

Resources

Books to read

Amazing Things Animals Do ed Donald J.Crump, (Washington, D.C.: National Geographic Society, 1989)

An Elephant Never Forgets Its Snorkel: How Animals Survive Without Tools and Gadgets by Lisa G. Evans (New York: Crown Publishers, 1992)

Animal Architects ed. Donald J. Crump (Washington, D. C.: National Geographic Society, 1987)

Animals Have Cousins Too: Five Surprising Relatives of Animals You Know by Geraldine Marshall Gutfreund (New York: Franklin Watts, 1990)

Animal Societies by Karen Gravelle (New York: Franklin Watts, 1993)

Animal Superstars: Biggest, Strongest, Fastest by Russell Freedman (Englewood Cliffs, N. J.: Prentice-Hall, 1984)

Animal Tracks and Traces by Kathleen V. Kudlinski (New York: Franklin Watts, 1991)

Camouflage: Nature's Defense by Nancy Warren Ferrell (New York: Franklin Watts, 1989)

Vanishing Species by Miles Barton (New York: Gloucester Press, 1991)

Zoos and Games Reserves by Miles Barton (New York: Gloucester Press, 1988)

Places to visit

The Arizona-Sonora Desert Museum
Tucson, Arizona
(602) 792-1530

The Bronx Zoo
International Wildlife Park
The Bronx, New York
(718) 367-1010

The Brookfield Zoo
Brookfield, Illinois
(708) 485-2200

The Cincinnati Zoo and Botanical Garden
Cincinnati, Ohio
(513) 281-4701

The Monkey Jungle
Miami, Florida
(305) 235-1611

National Zoological Park
Washington, D.C.
(202) 673-4717

San Diego Wild Animal Park
Escondido, California
(619) 234-6541

Index

Additional photographs:
FLPA 7(tr); © Jany Sauvanet/NHPA 21(tr); Zefa Picture Library
8(bl), 9(bl), 11(tr), 13(tl), 14(bl), 17(tr), 19(br), 23(bl), 25(tr), 27(bl).